Inspirations

The Wonders of Weather in Pictures and Scripture

PHOTOGRAPHY BY *Jim Reed*

FARCOUNTRY
PRESS

Dedicated to those who still believe.

ISBN 10: 1-56037-397-0
ISBN 13: 978-1-56037-397-1
Photography © 2006 by Jim Reed
© 2006 by Farcountry Press

All scripture is from the New International Version of the Bible.

For more information about our books, write Farcountry Press, P.O. Box 5630, Helena, MT 59604; call (800) 821-3874; or visit www.farcountrypress.com.

Created, produced, and designed in the United States. Printed in China.

10 09 08 07 06 1 2 3 4 5

The aurora borealis at sunrise in Alaska near the Arctic Circle.

*H*ow great are his signs,

how mighty his wonders!

His kingdom is an eternal kingdom;

his dominion endures from

generation to generation.

DANIEL 4:3

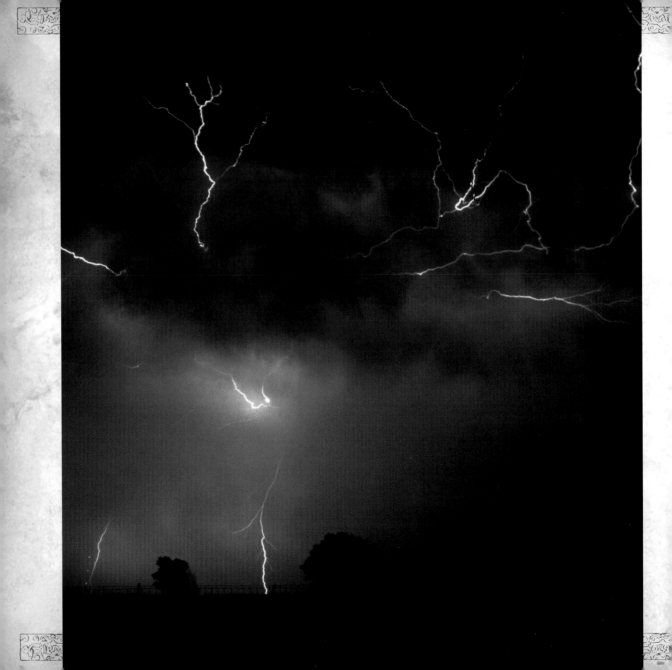

The voice of the Lord strikes with flashes of lightning.

PSALM 29:7

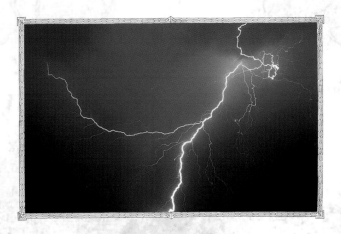

Lightning crackles over America's heartland.

For you were once darkness, but now you are light in the Lord. Live as children of light.

EPHESIANS 5:8

A supercell thunderstorm moves over southern Kansas at twilight.

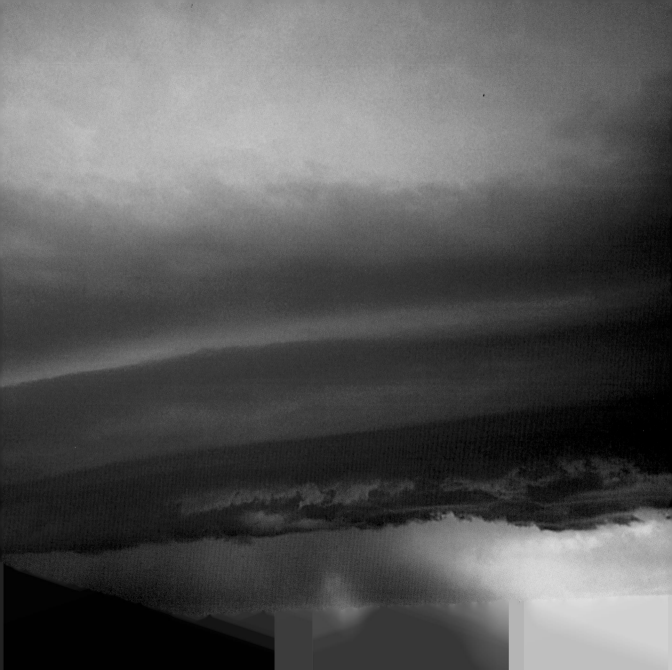

Proclaim the power of God, whose majesty is over Israel,

whose power is in the skies.

You are awesome, O God, in your sanctuary;

the God of Israel gives power and strength

to his people.

PSALM 68:34-35

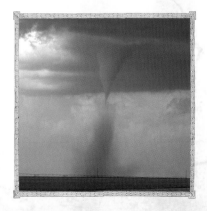

Tornadoes whirl across western Kansas.

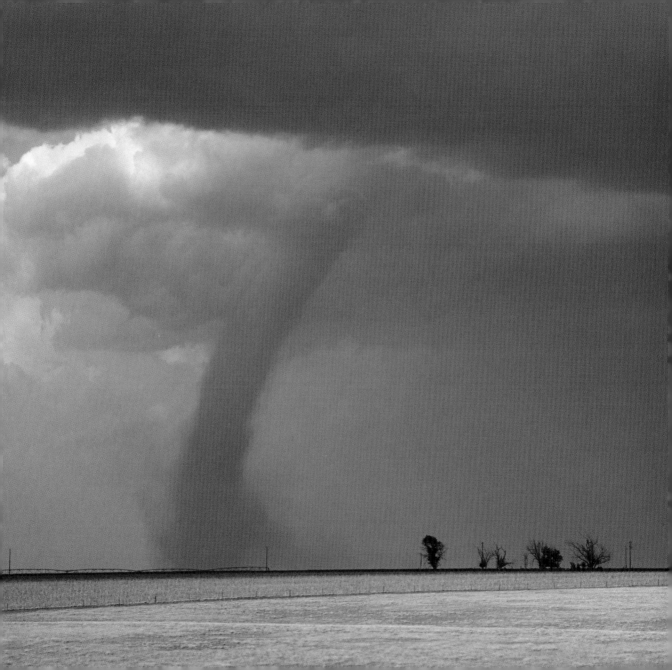

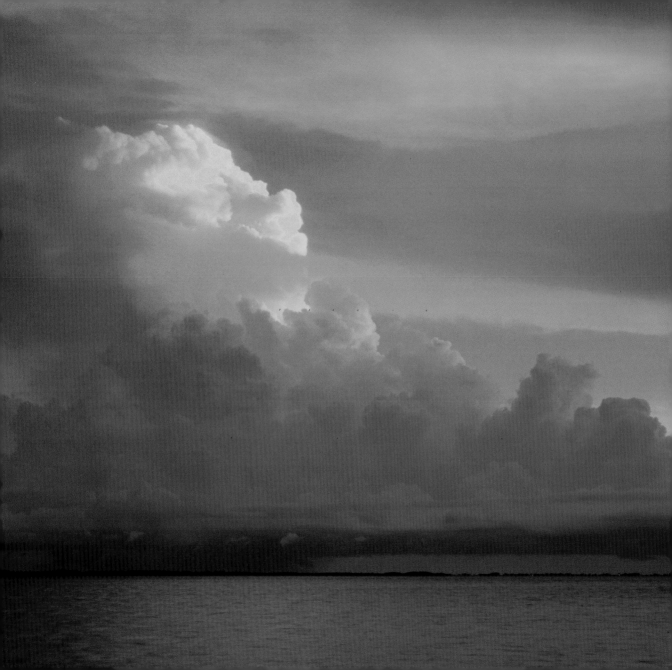

The voice of the Lord is over the waters;

the God of glory thunders,

the Lord thunders over the mighty waters.

The voice of the Lord is powerful;

the voice of the Lord is majestic.

PSALM 29:3-4

An outer band of Hurricane Isidore approaches Florida.

Be patient, then, brothers, until the Lord's coming.

See how the farmer waits for the land to yield

its valuable crop and how patient he is for the

autumn and spring rains.

You too, be patient and stand firm, because

the Lord's coming is near.

JAMES 5:7-8

A mesocyclone spins over Midwestern farmland.

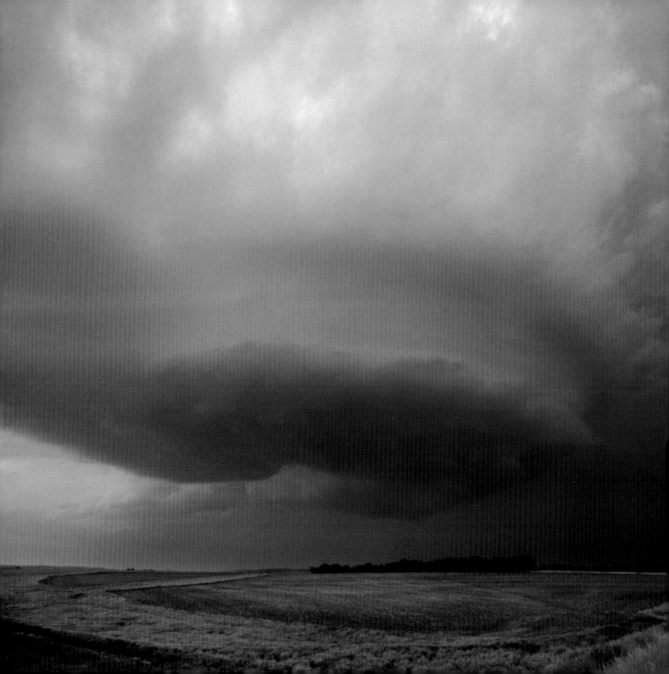

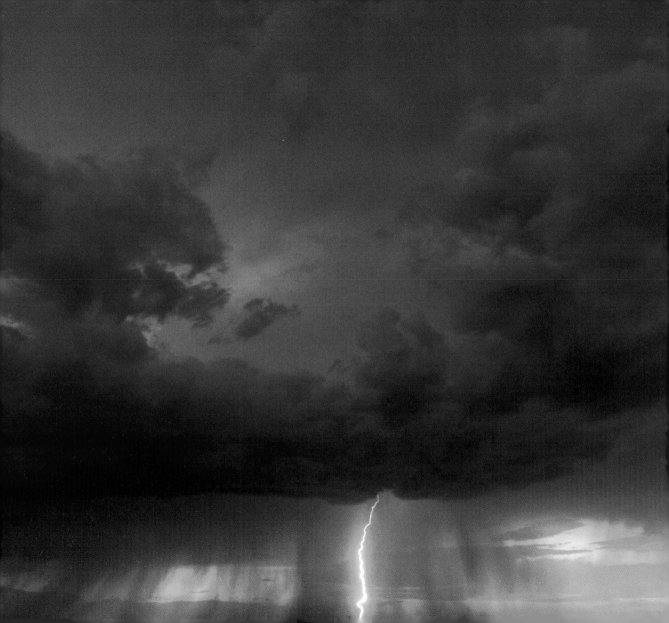

Therefore everyone who hears these words of mine and puts them into practice is like a wise man who built his house on the rock. The rain came down, the streams rose, and the winds blew and beat against that house; yet it did not fall, because it had its foundation on the rock.—

MATTHEW 7:24-25

ABOVE: *A colorful sunset develops over North Myrtle Beach in South Carolina.*
LEFT: *A cloud-to-ground lightning bolt strikes at sunset in Nebraska.*

Be still, and know that I am God.

PSALM 46:10

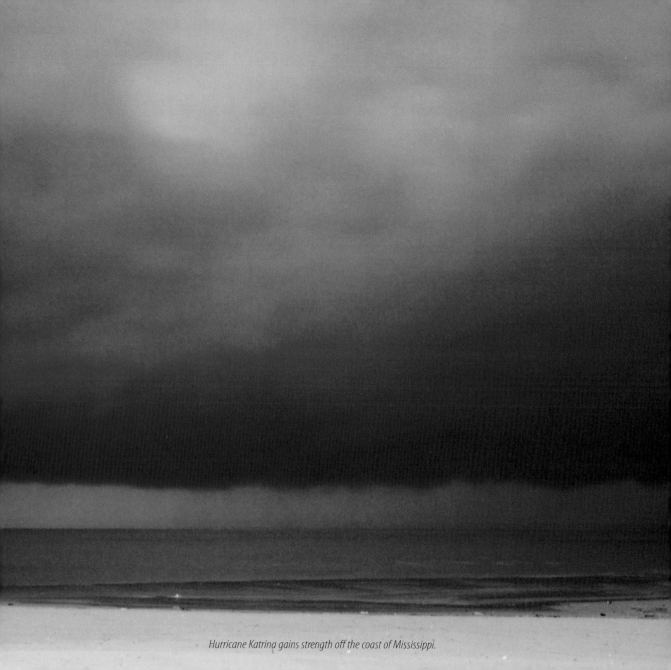

Hurricane Katrina gains strength off the coast of Mississippi.

But let all who take refuge in you

be glad; let them ever sing for joy.

Spread your protection over them,

that those who love your name

may rejoice in you.

For surely, O Lord, you bless the

righteous; you surround them with

your favor as with a shield.

PSALM 5:11-12

A thunderstorm brings much-needed rain to north-central Nebraska.

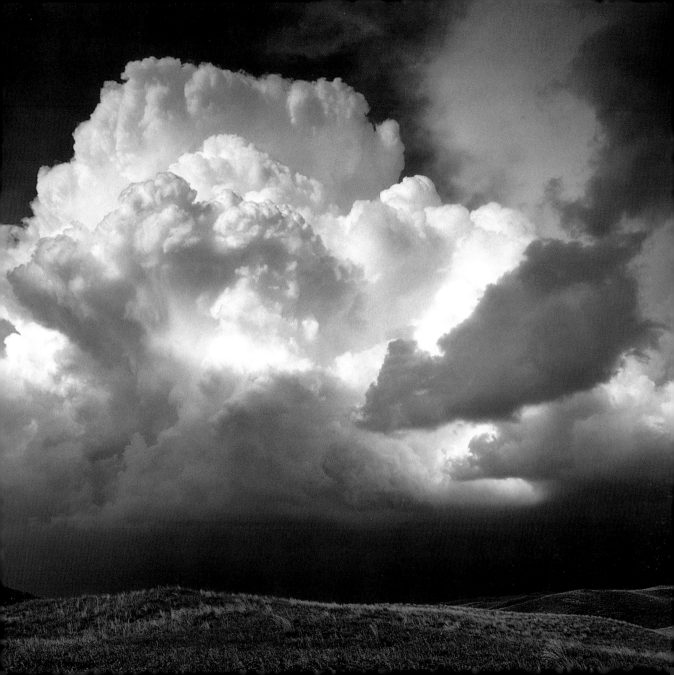

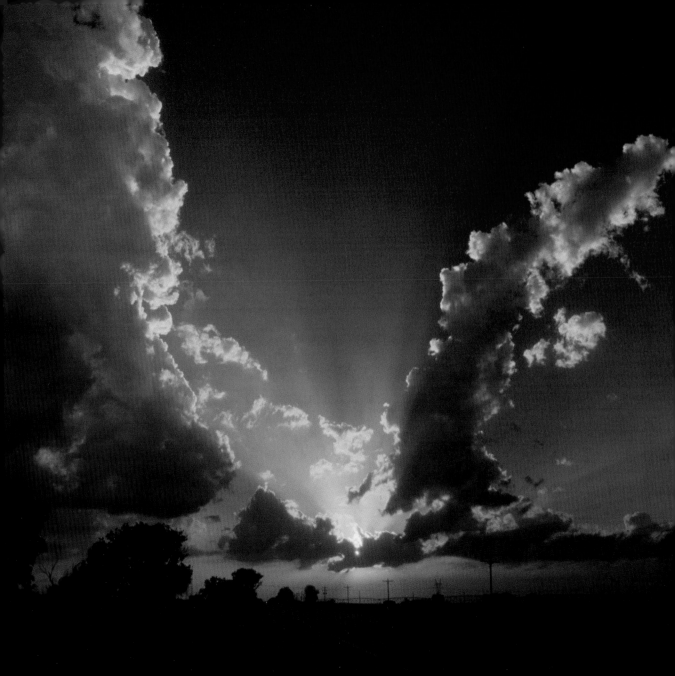

Yours, O Lord, is the greatness and the

power and the glory and the majesty

and the splendor, for everything in

heaven and earth is yours.

Yours, O Lord, is the kingdom;

you are exalted as head over all.

1 CHRONICLES 29:11

Cumulus clouds drift across the setting sun in southern Nebraska.

O̶ut of the brightness of his presence

bolts of lightning blazed forth.

The Lord thundered from heaven;

the voice of the Most High

resounded.

2 SAMUEL 22:13-14

Lightning ignites the sky over northern Texas.

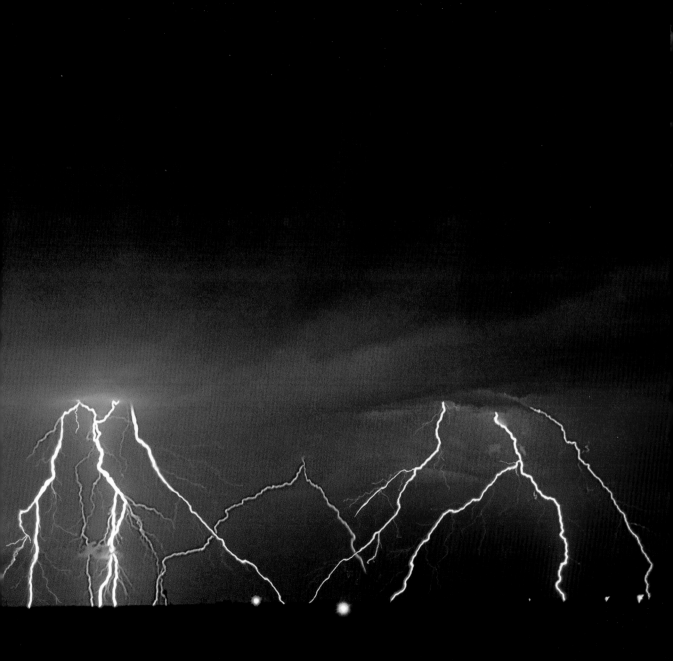

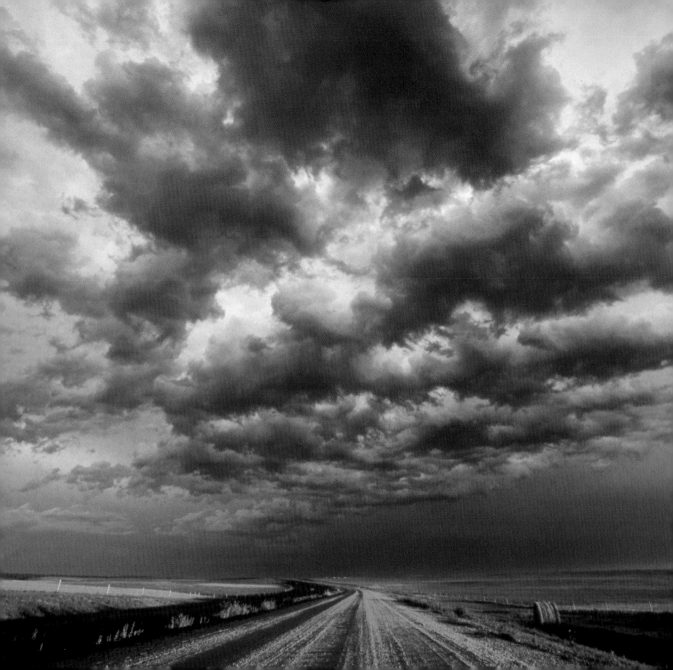

As long as the earth endures,

seedtime and harvest,

cold and heat,

summer and winter,

day and night

will never cease.

GENESIS 8:22

A thunderstorm moves over an isolated road in South Dakota at sunset.

He has made everything beautiful in its time. He has also set eternity in the hearts of men; yet they cannot fathom what God has done from beginning to end.

ECCLESIASTES 3:11

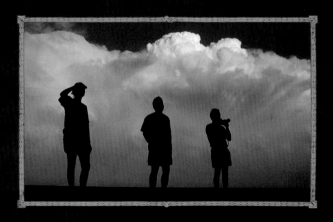

ABOVE: *People stand in awe of a grand cloud formation in Kansas.*
RIGHT: *Mammatus clouds glow at sunset in Kansas.*

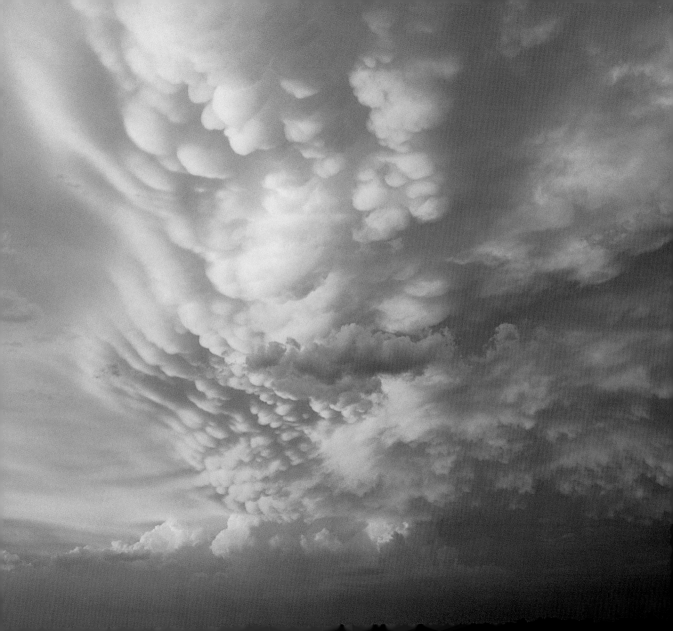

For great is your love, reaching to the heavens;

your faithfulness reaches to the skies.

Be exalted, O God, above the heavens;

let your glory be over all the earth.

PSALM 57:10–11

Cumulus clouds and crepuscular rays appear over Kansas.

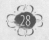

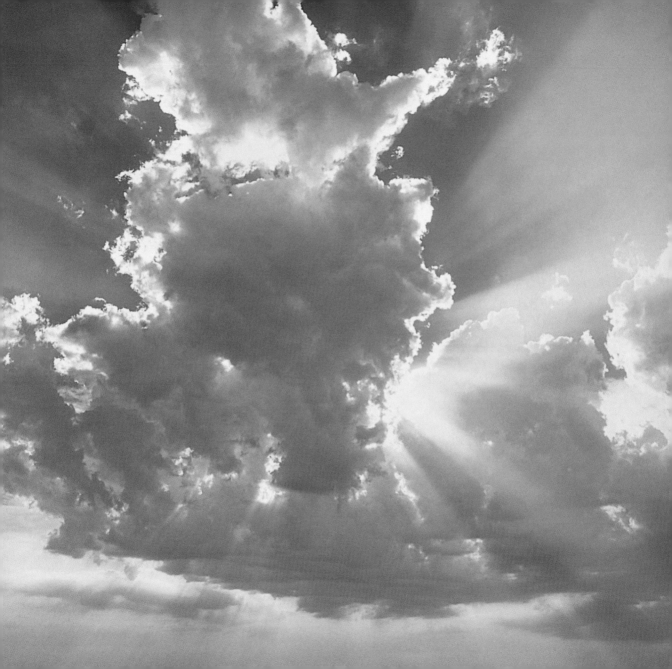

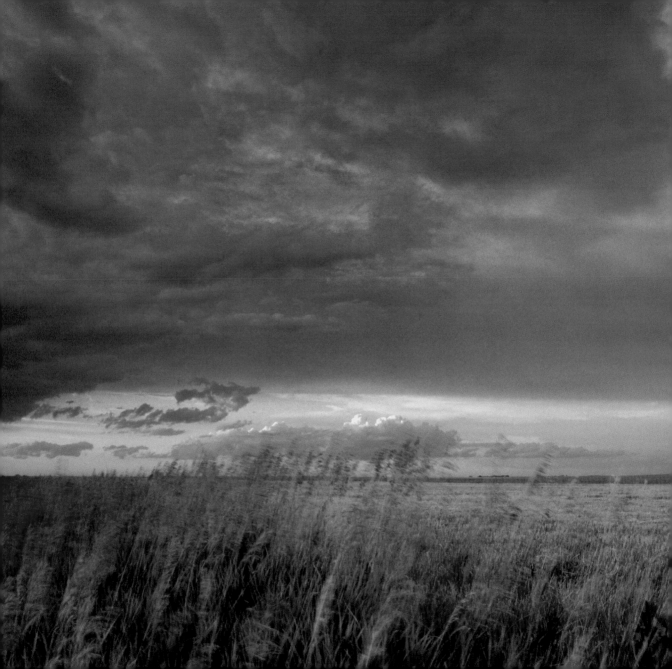

My own hand laid the foundations

of the earth,

and my right hand spread

out the heavens;

when I summon them,

they all stand up together.

ISAIAH 48:13

So do not fear, for I am with you;

do not be dismayed,

for I am your God.

I will strengthen you

and help you;

I will uphold you with

my righteous right hand.

ISAIAH 41:10

Over Kansas, lightning flashes against a vivid red sky.

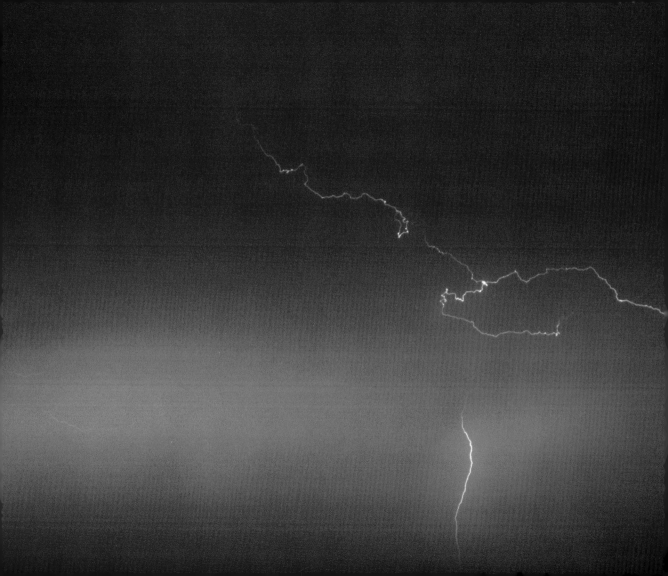

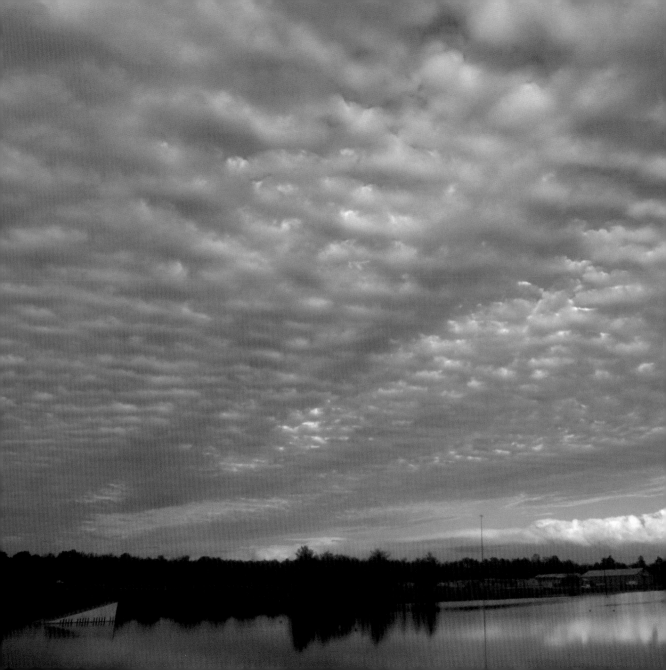

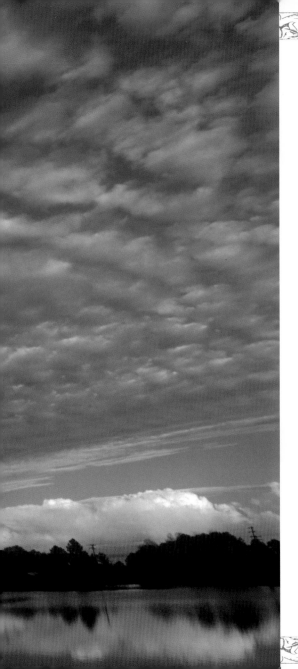

\mathcal{P}eace I leave with you;
my peace I give you.
I do not give to you as
the world gives.
Do not let your hearts
be troubled and do not
be afraid.

JOHN 14:27

*Alocumulus clouds stretch across the sky
above a South Carolina lake.*

But I will sing of your strength,

 in the morning I will sing of your love;

 for you are my fortress,

 my refuge in times of trouble.

PSALM 59:16

A tornado roars across a dirt road less than 500 feet from a Kansas state police car.

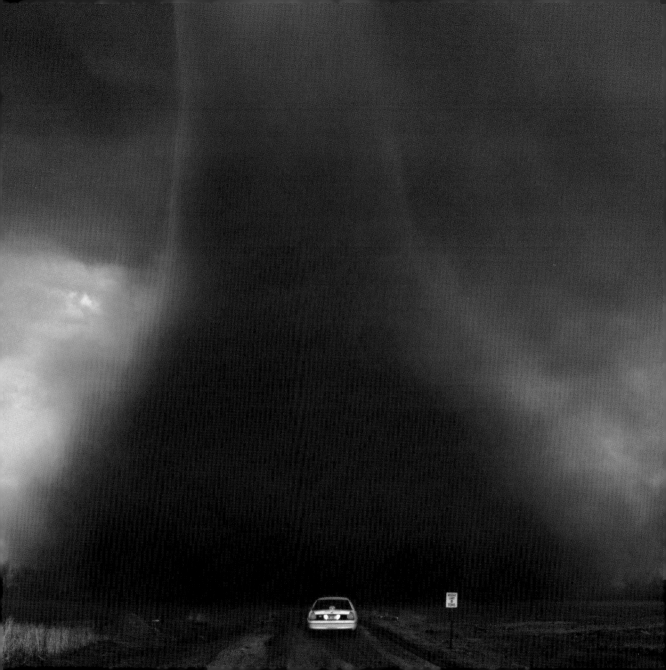

Arise, shine, for your light has come,

and the glory of the Lord rises upon you.

See, darkness covers the earth and thick

darkness is over the peoples,

but the Lord rises upon you and his

glory appears over you.

ISAIAH 60:1-2

Lightning strikes beneath a supercell thunderstorm at twilight in south-central Kansas.

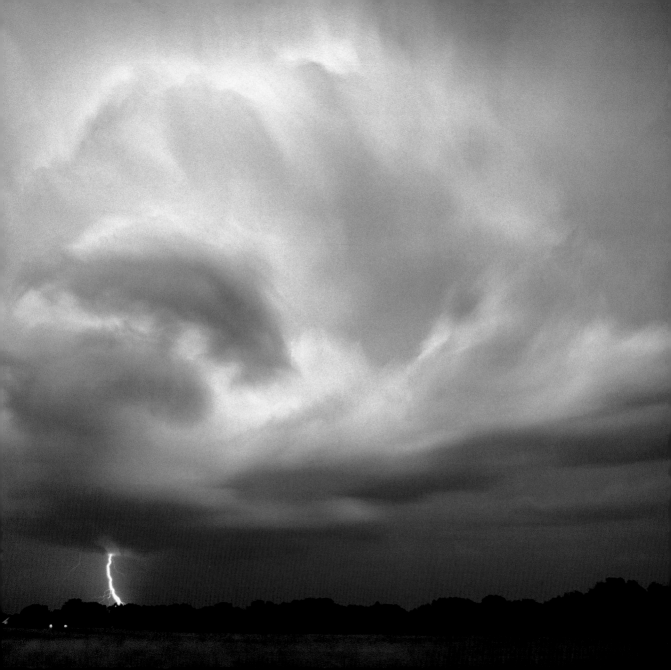

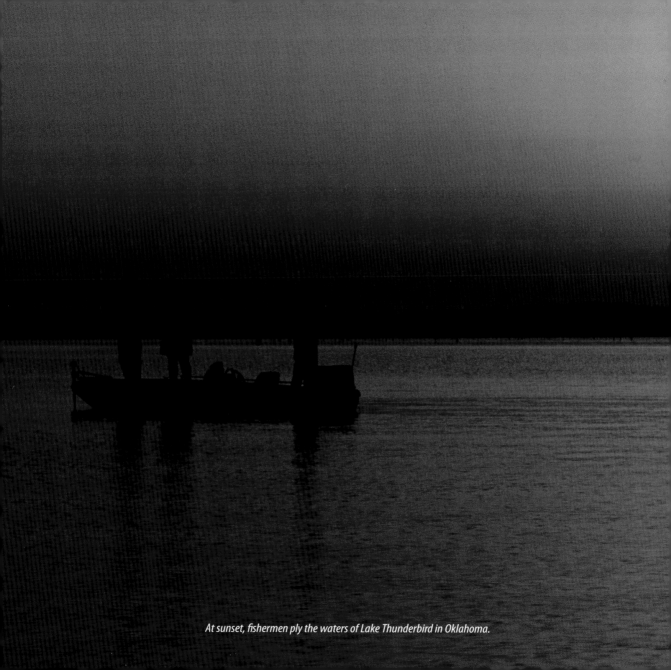

At sunset, fishermen ply the waters of Lake Thunderbird in Oklahoma.

Finally, all of you, live in harmony with one another; be sympathetic, love as brothers, be compassionate and humble.

1 PETER 3:8

Though the mountains be shaken and the hills be removed,

yet my unfailing love for you will not be shaken

nor my covenant of peace be removed.

ISAIAH 54:10

ABOVE: *An ice-coated tree glistens in southern Kansas.*
RIGHT: *Winter clouds pass over the Columbia Ice Fields in Alberta, Canada.*

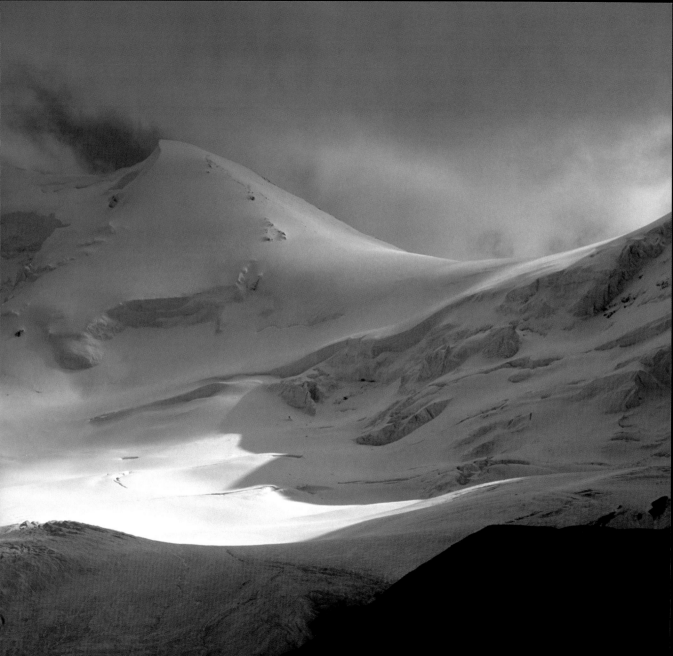

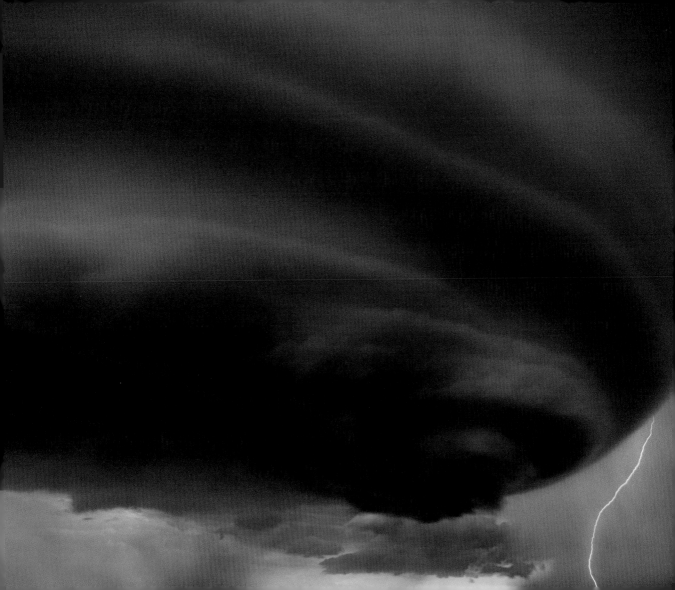

For since the creation of the world

God's invisible qualities—

his eternal power and divine nature—

have been clearly seen,

being understood from what

has been made, so that men are

without excuse.—

ROMANS 1:20

A lone lightning bolt strikes the ground beneath an isolated supercell thunderstorm at sunset in south-central Kansas.

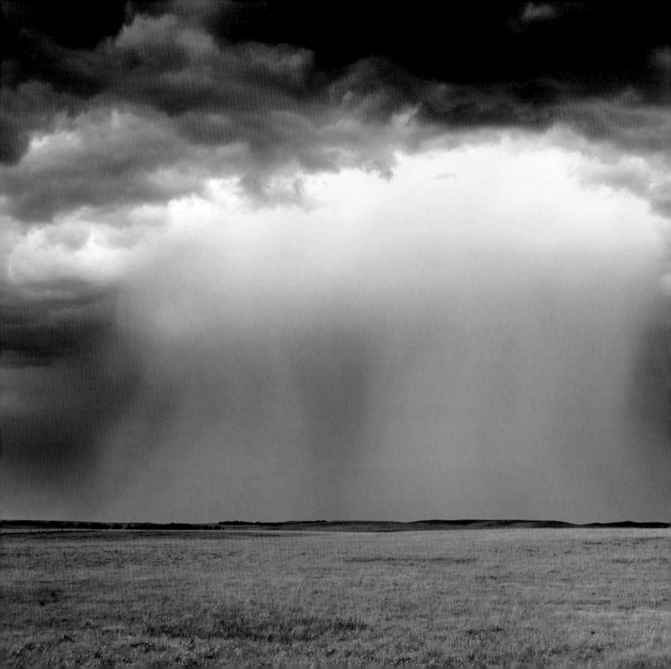

Let us acknowledge the Lord;

let us press on to acknowledge him.

As surely as the sun rises, he will appear;

he will come to us like the winter rains,

like the spring rains that water the earth.

HOSEA 6:3

ABOVE: *Wheat blows gently in the wind.*
LEFT: *A curtain of rain and hail drifts across rural Nebraska.*

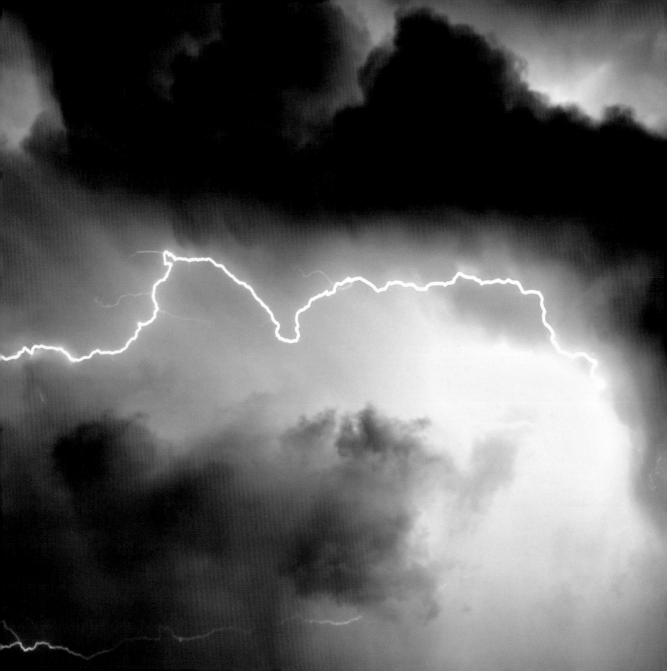

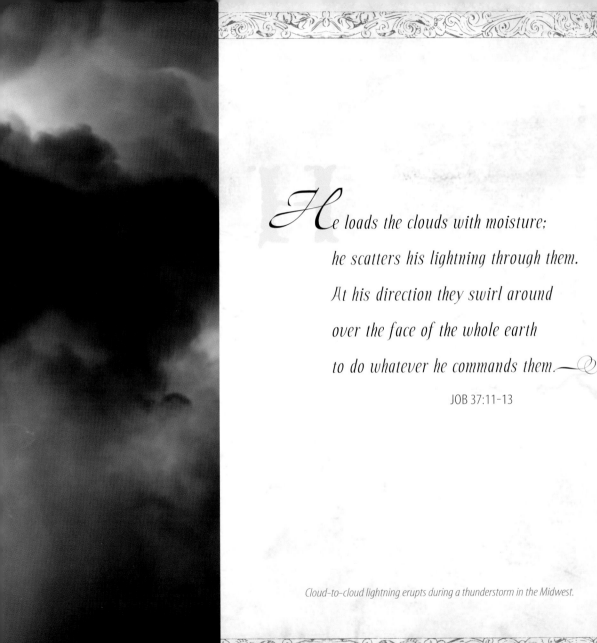

He loads the clouds with moisture;

he scatters his lightning through them.

At his direction they swirl around

over the face of the whole earth

to do whatever he commands them.

JOB 37:11-13

Cloud-to-cloud lightning erupts during a thunderstorm in the Midwest.

\mathcal{L}ift your eyes and look to the heavens:

Who created all these?

He who brings out the starry host one by one,

and calls them each by name.

Because of his great power and mighty strength,

not one of them is missing.

ISAIAH 40:26

A rare burst of red aurora appears over Lake Wateree in South Carolina.

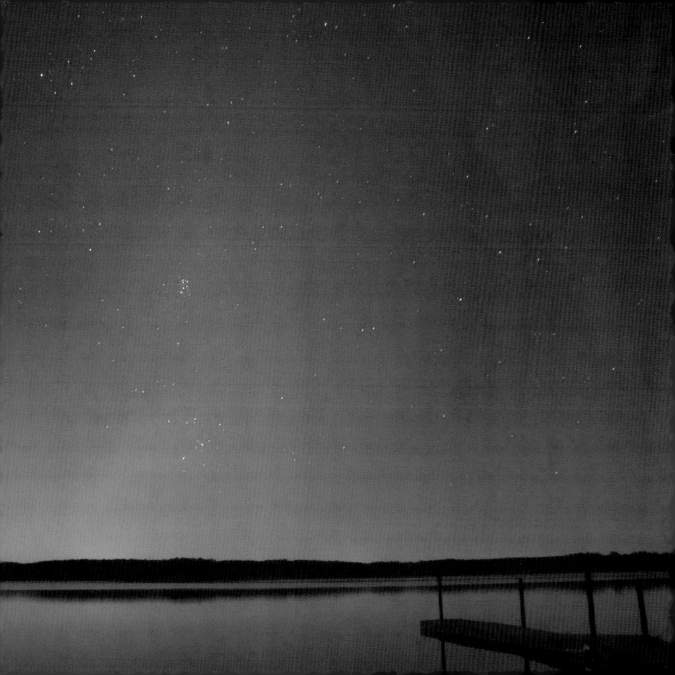

\mathscr{H}e makes me lie down in green pastures,

he leads me beside quiet waters,

he restores my soul.

He guides me in paths of righteousness

for his name's sake.

PSALM 23:2-3

Waves wash ashore at Myrtle Beach in South Carolina.

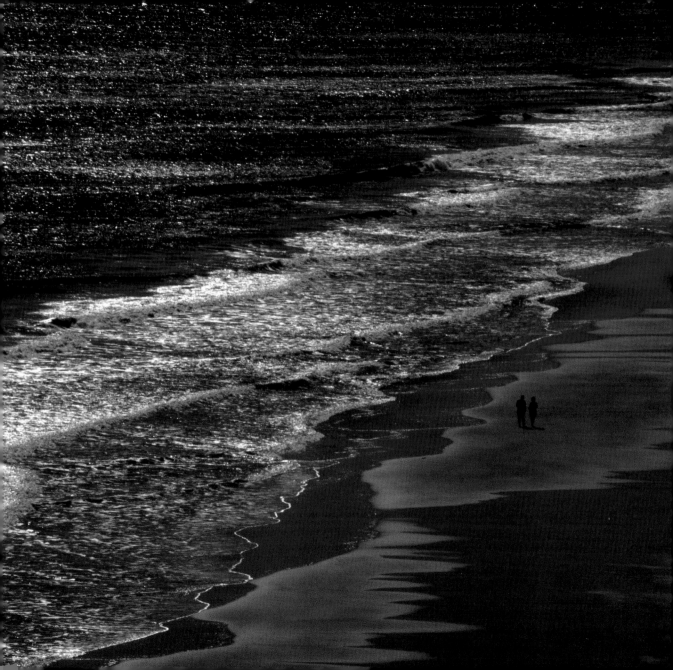

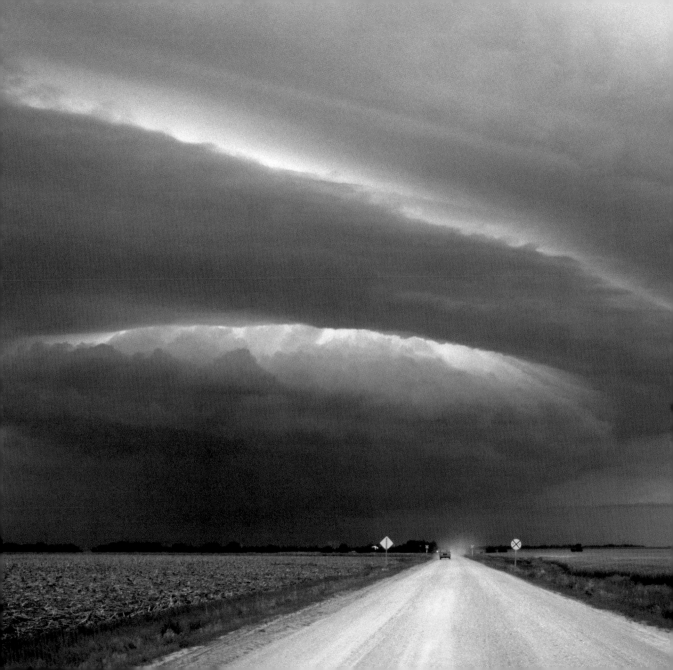

I will lead the blind by ways they have not known,

along unfamiliar paths I will guide them;

I will turn the darkness into light before them

and make the rough places smooth.

These are the things I will do;

I will not forsake them.

ISAIAH 42:16

ABOVE: *Monarch butterflies gather on a sunflower during stormy weather in Kansas.*
LEFT: *A lone driver escapes the path of a tornadic thunderstorm in Kansas.*

Let the morning bring me word

of your unfailing love, for I

have put my trust in you.

Show me the way I should go,

for to you I lift up

my soul.

PSALM 143:8

Dawn breaks at Cape Hatteras in North Carolina.

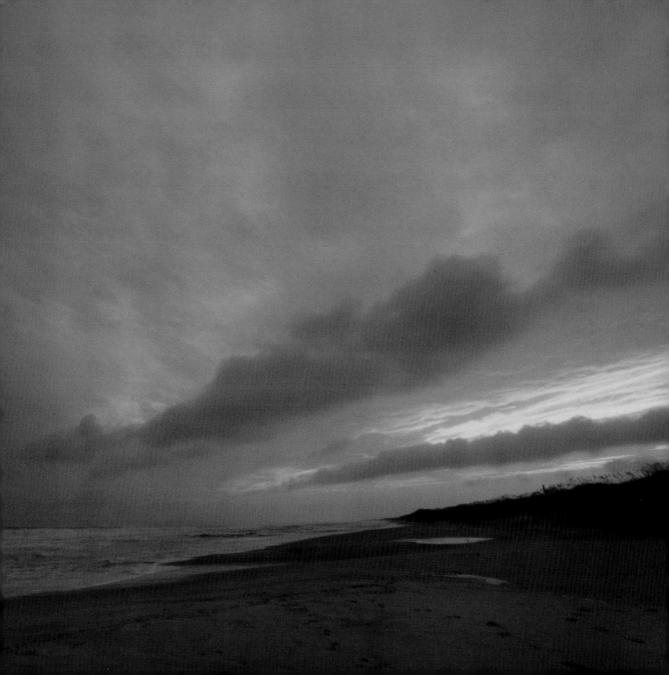

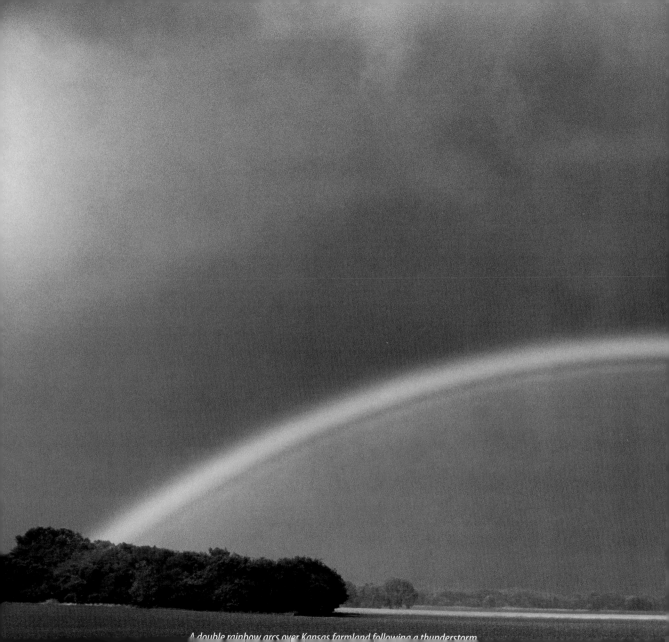

A double rainbow arcs over Kansas farmland following a thunderstorm.

*K*now therefore that the Lord your God is God;
he is the faithful God, keeping his covenant of
love to a thousand generations of those who
love him and keep his commands.

DEUTERONOMY 7:9

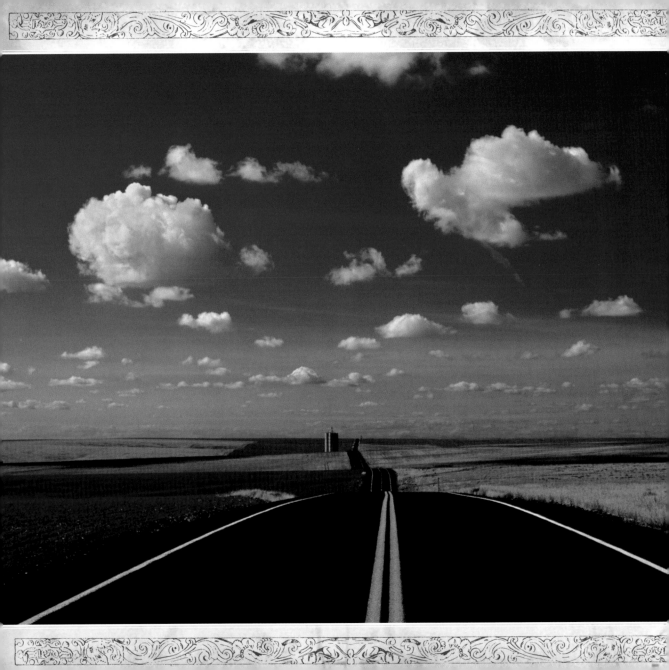

Do not be anxious about anything,

but in everything, by prayer and petition,

with thanksgiving, present your requests to God.

And the peace of God, which transcends all

understanding, will guard your hearts and

your minds in Christ Jesus.

PHILIPPIANS 4:6-7

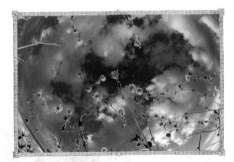

ABOVE: *Bright-yellow wildflowers reach for the sky in Death Valley National Park.*
LEFT: *Cumulus clouds dot the sky above a seemingly endless highway in eastern Washington.*

61

Come to me, all you who are

weary and burdened,

and I will give you rest.

Take my yoke upon you

and learn from me, for I am

gentle and humble in heart,

and you will find rest for

your souls.

MATTHEW 11:28-29

Sunrise casts a path of golden light across the Atlantic Ocean.

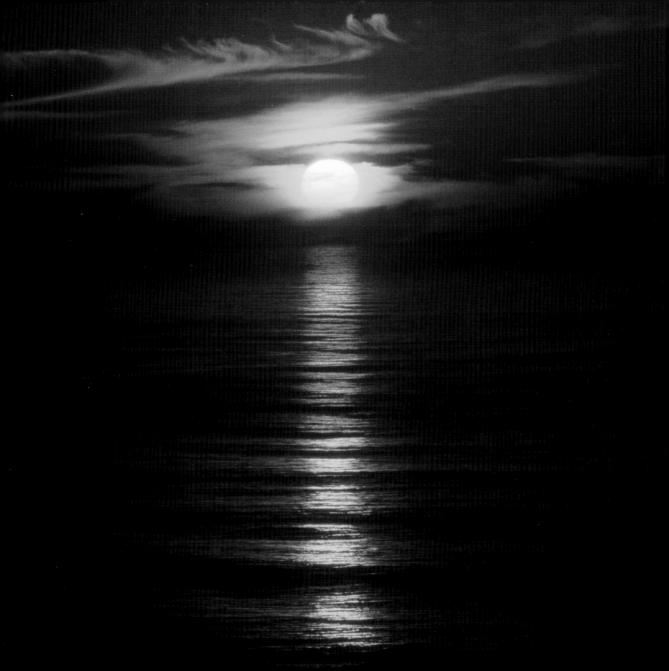

© Katherine Bay

*J*im Reed is recognized as one of the world's most accomplished extreme-weather photographer. A professional storm chaser, Jim has documented nearly every type of weather phenomenon, including tornadoes, blizzards, floods, and geomagnetic storms. He has photographed fifteen hurricanes, including Hurricane Katrina.

Jim's work appears in numerous books and publications, including National Geographic, the New York Times, and Scientific American. He is co-author of the book Hurricane Katrina: Through the Eyes of Storm Chasers. His photographs have been featured on ABC's "Good Morning America" and NBC's "The Today Show," as well as on several other major network programs.

Jim encourages everyone to own a NOAA weather radio. Visit www.jimreedphoto.com to see more of his work.